Handmade Books

LARK STUDIO SERIES

LARK CRAFTS

A Division of
Sterling Publishing Co., Inc.
New York / London

Library of Congress Cataloging-in-Publication Data

Lark studio series: handmade books / [senior editor, Ray Hemachandra]. – 1st ed.
 p. cm. – (Lark studio series)
 Includes index.
 ISBN 978-1-60059-682-7 (pb-flexibound : alk. paper)
 1. Book design. 2. Bookbinding. I. Hemachandra, Ray. II. Lark Books.
 Z271.L46 2010
 090--dc22

 2010004950

SENIOR EDITOR
Ray Hemachandra

EDITORS
Julie Hale
Larry Shea

ART DIRECTOR
Chris Bryant

LAYOUT
Skip Wade

COVER DESIGNER
Chris Bryant

10 9 8 7 6 5 4 3 2 1

First Edition

Published by Lark Books, A Division of
Sterling Publishing Co., Inc.
387 Park Avenue South, New York, NY 10016

Text © 2010, Lark Books, A Division of Sterling Publishing Co., Inc.
The books in this book appeared in *500 Handmade Books*, juried by Steve Miller.

Photography © 2010, Artist/Photographer

Distributed in Canada by Sterling Publishing,
c/o Canadian Manda Group, 165 Dufferin Street
Toronto, Ontario, Canada M6K 3H6

Distributed in the United Kingdom by GMC Distribution Services,
Castle Place, 166 High Street, Lewes, East Sussex, England BN7 1XU

Distributed in Australia by Capricorn Link (Australia) Pty Ltd.,
P.O. Box 704, Windsor, NSW 2756 Australia

COVER
Geraldine A. Newfry
HOMAGE TO AUDUBON
PHOTO BY LARRY SANDERS

BACK COVER
Alice Austin
RED, YELLOW, BLUE
PHOTO BY ARTIST

If you have questions or comments about this book, please contact:
LARK CRAFTS | 67 Broadway | Asheville, NC 28801 | 828-253-0467

Manufactured in China

ISBN 13: 978-1-60059-682-7

For information about special sales, contact the Sterling Special Sales Department at
800-805-5489 or **specialsales@sterlingpub.com**.

CONTENTS

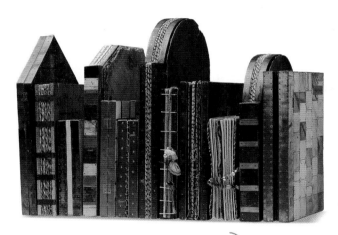

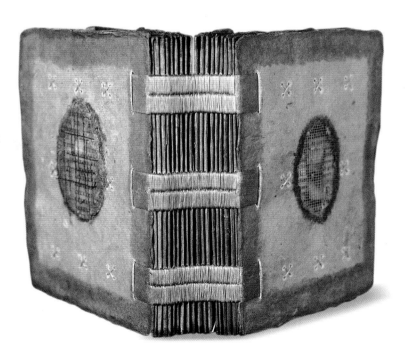

INTRODUCTION

The Lark Studio Series is designed to give you an insider's look at some of the most exciting work being made by artists today. The handmade books we've selected capture the exotic, experimental, yet often still old-fashioned aesthetic of this popular craft medium. Book artists respect the tradition of their craft even while they're engaged in innovative play. Like you, they start by turning the page.

Elysa Voshell

THE INNER LIVES OF FLEETING SHADOWS

8¼ x 5¾ x 2 inches (21 x 14.6 x 5 cm)

Vegetable parchment, acrylic;
Coptic binding; molded, inkjet printed

PHOTO BY ARTIST

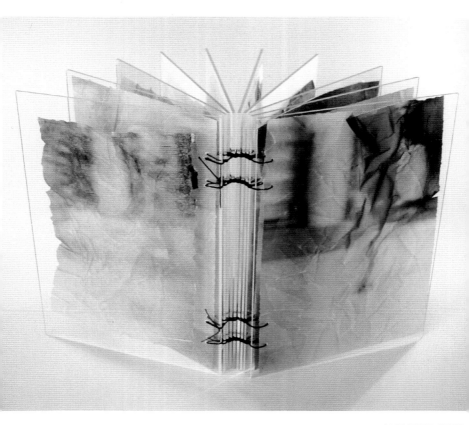

Robbin Ami Silverberg

SPUN INTO GOLD: FIRST 100 WORDS
7 x 5 1/4 x 1 1/2 inches (17.8 x 13.3 x 3.8 cm)

Dobbin Mill kozo papers; case binding; archival
inkjet printed, hand-cut and spun paper

PHOTO BY GREGG STANGER

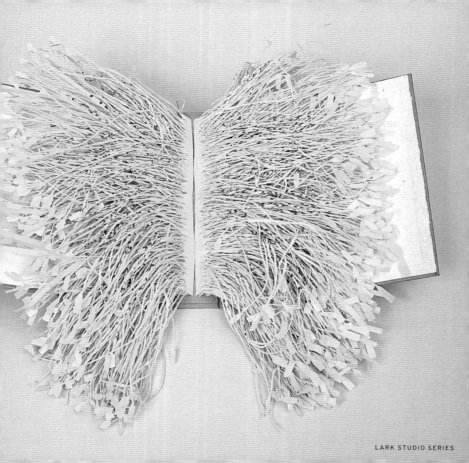

Peter Thomas
Donna Thomas

Y2K3MS: UKULELE SERIES BOOK #2, UKULELE ACCORDION

18 x 6 x 3 inches (45.7 x 15.2 x 7.6 cm)

Ukulele, leather, leather onlay, sound hole, handmade paper; accordion binding; handwritten, illustrated

PHOTO BY ROB THOMAS

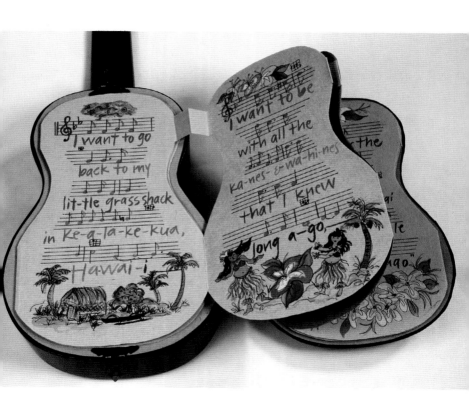

David Hodges

ORANGE ALBUM
6 7/8 x 9 13/16 x 9/16 inches (17.4 x 25 x 1.4 cm)

Canson Mi-Teintes paper, Chrome gold buckram; Japanese stitch, five-hole procedure; hand stitched, vertical gold tooling

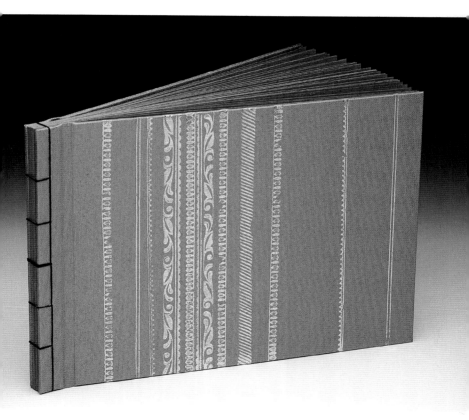

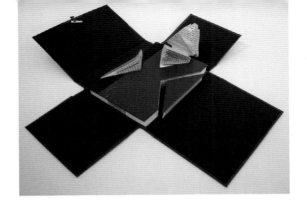

Jennifer Evans Kinsley

EXCLUSION
9 x 6 x 2 inches (22.9 x 15.2 x 5 cm)

Altered book, cloth, Canson cover stock, silk ribbon,
bone closure, ink; perfect binding; saw-cut scroll

PHOTOS BY MICHELLE SALRIN STITZLEIN

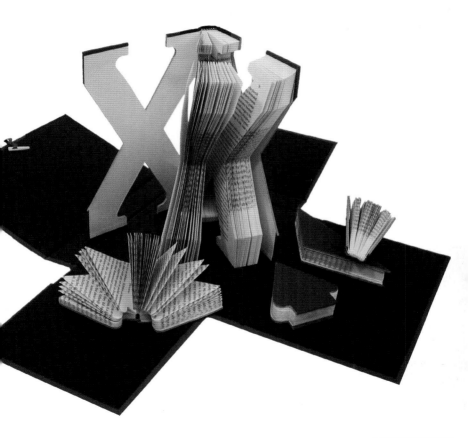

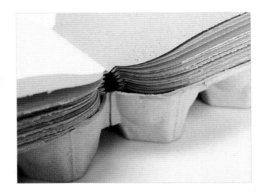

Erin Zamrzla

HALF-DOZEN

3¹/₂ x 6 x 4 inches (8.9 x 15.2 x 10.2 cm)

Egg carton, transparent and colored papers,
linen thread; Coptic binding

PHOTOS BY ARTIST

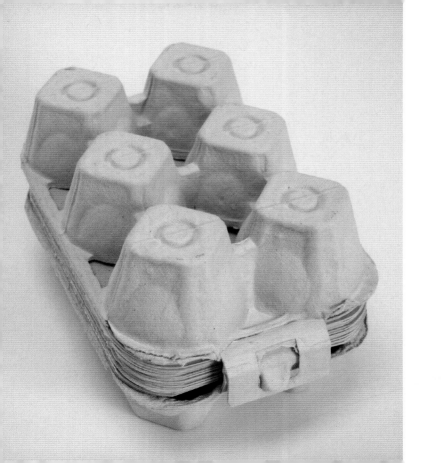

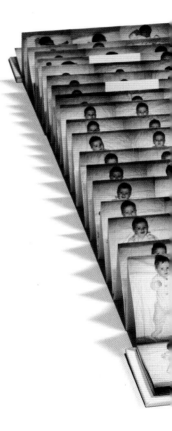

Michael A. Henninger

OSCAR 365
4 x 18¾ x 1¼ inches (10.2 x 47.6 x 3.2 cm)

Paper; accordion binding; digital printing

PHOTO BY ARTIST

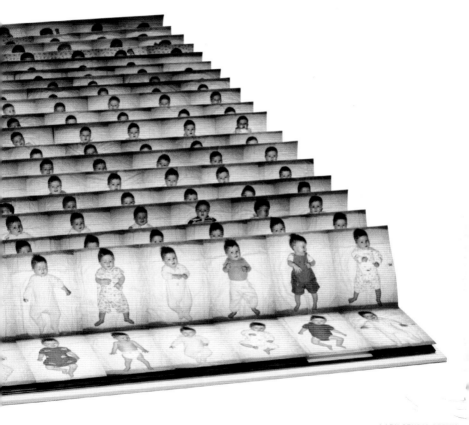

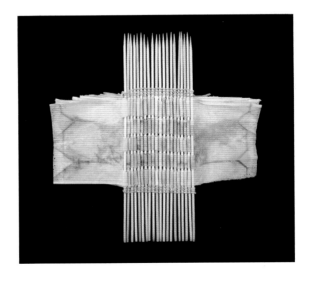

Heather Crossley

TI (TEA)

8 x 8 x 8 inches (20.3 x 20.3 x 20.3 cm)

Used tea bags, sticks, beads, waxed
linen thread; piano hinge binding

PHOTOS BY ARTIST

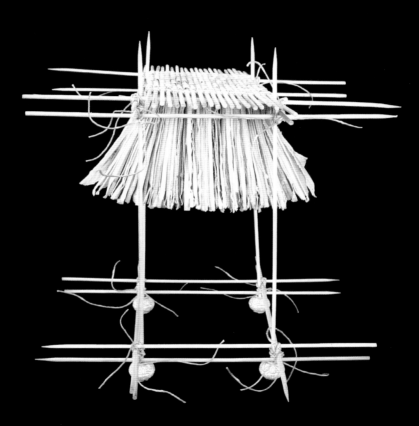

Sharon McCartney

MOONLIGHT AND MUSIC

3¼ x 3¼ x ½ inches (8.3 x 8.3 x 1.3 cm)

Rice paper, vintage papers, stamps, thread, watercolor, acrylic; double flap page fold-outs; painted, drawn, photocopy transfer, gelatin printing, hand and machine stitched

PHOTO BY JOHN POLAK PHOTOGRAPHY

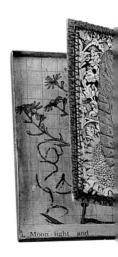

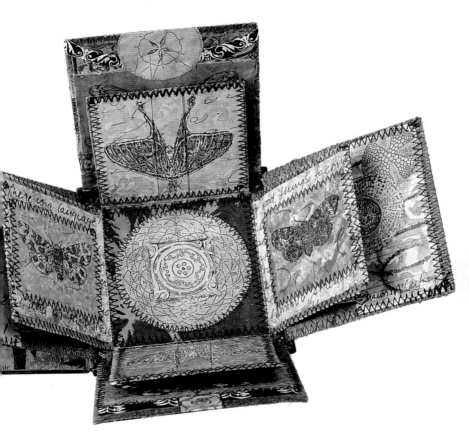

Mira Coviensky

CRIBBAGE TIME
13 x 3 x 2½ inches (33 x 7.6 x 6.4 cm)

Plastic cribbage board, pegs, aluminum leaf, Pantypress,
cork, and kozuke papers, found object, family photographs;
accordion binding; laser printed, collage, handwritten

PHOTOS BY PIITZ-NAZAR

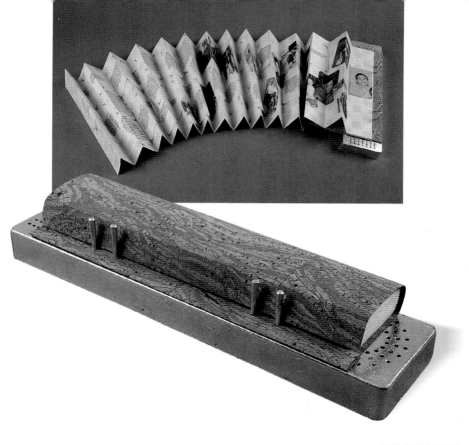

Melodie Carr

THE DOT AND THE LINE: DUAL VISION VERSION

7 x 10 x 1¾ inches (17.8 x 25.4 x 4.4 cm)

Arch text-wove and Braille papers, Nigerian goatskin, laminated paper,
silk thread, tactile graphics; letterpress, Braille and inkjet-printed text

PHOTOS BY ARTIST

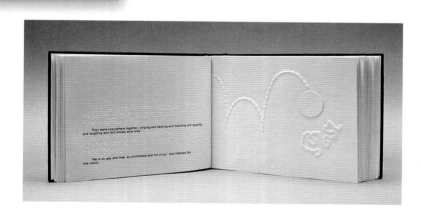

They were everywhere together; singing and dancing and frolicking and laughing and laughing and lord knows what else.

"She is so gay and free, so uninhibited and full of joy," she informed the time coolly.

Claudia Lee

UNTITLED

4 x 3 x ½ inches (10.2 x 7.6 x 1.3 cm)

Handmade and commercial papers, natural dyes,
waxed linen; Coptic binding; wax resist, stitched

PHOTO BY JOHN LUCAS

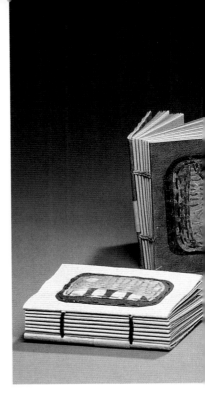

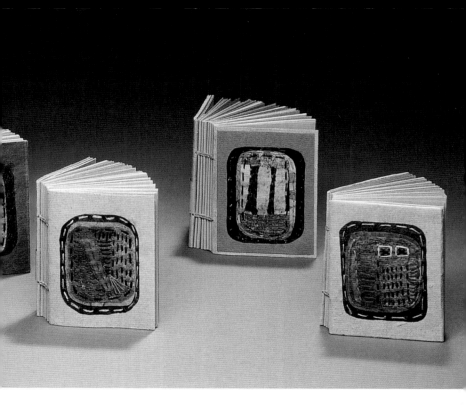

Rachel Melis

SEED MIX
1 x 2 x ¼ to 3 x 3 x ¼ inches (2.5 x 5 x 0.6 to 7.6 x 7.6 x 0.6 cm)

Paper, linen thread, linen cord, beeswax;
letterpress, dipped, burned

PHOTO BY ARTIST

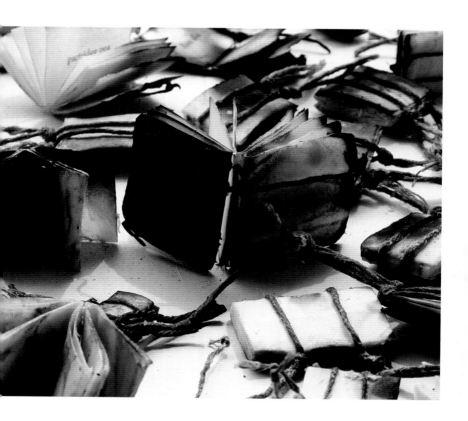

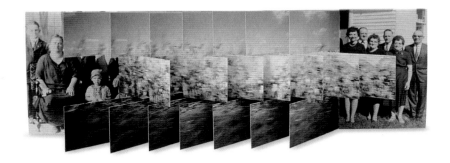

Karen Hanmer

SUCCESSION

Closed: 7 x 5 x ¾ inches (17.8 x 12.7 x 1.9 cm)

Pigment inkjet prints, flag book

PHOTOS BY ARTIST

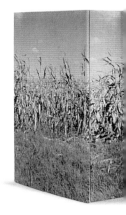

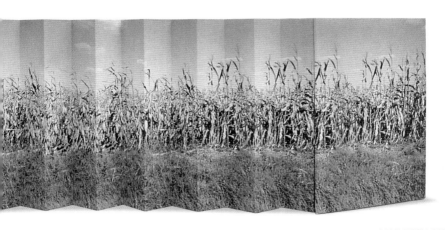

Judith A. Hoffman

7 EXTINCTION EVENTS
6$\frac{1}{2}$ x 7 x 8 inches (16.5 x 17.8 x 20.3 cm)

Arches watercolor paper, plastic dinosaur, copper;
spiral binding; etched, hammered, painted, collaged

PHOTO BY ARTIST

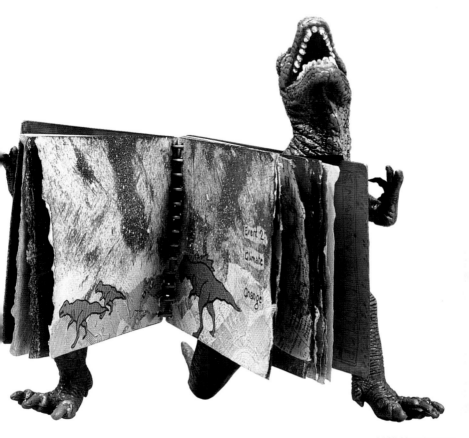

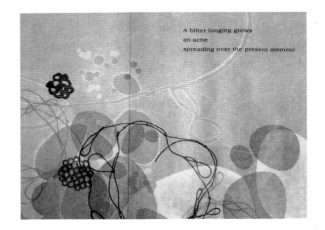

A bitter longing grows
an ache
spreading over the present moment

Macy Chadwick
Lisa Onstad

AGGREGATE MEMORY
8⅝ x 5¼ x ¼ inches (21.9 x 13.3 x 0.6 cm)

Gasen and Hanji papers, hard covers; leporello two-sided accordion binding;
letterpress, pressure prints, relief prints, polymer plates;
text by Lisa Onstad and Macy Chadwick

PHOTOS BY MACY CHADWICK

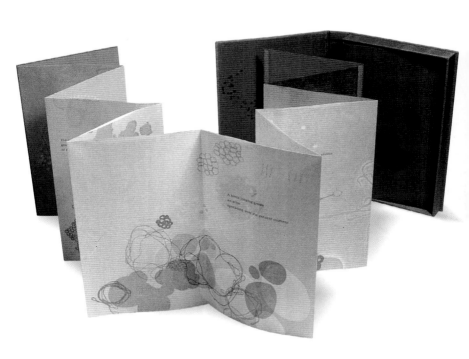

Susan Lenz

SOME THINGS I'LL NEVER KNOW

6¹/₂ x 13¹/₂ x 13¹/₂ inches (16.5 x 34.3 x 34.3 cm)

Assorted yarns and thread, assorted scraps of foreign text, buttons;
free motion machine zigzags, stitching, wrapped paper

PHOTOS BY ARTIST

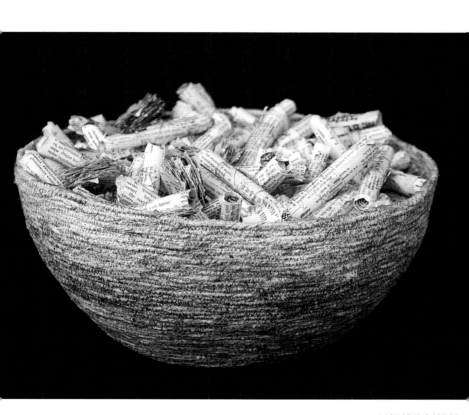

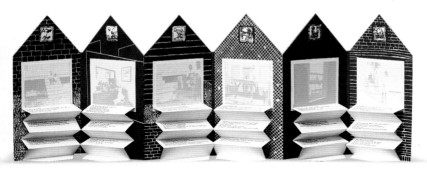

Clarissa T. Sligh

WHAT'S HAPPENING WITH MOMMA?
11 x 38¼ inches (27.9 x 97.2 cm)

Coventry and Stonehenge papers; accordion
 binding; silkscreened, letterpress

PHOTOS BY D. JAMES DEE

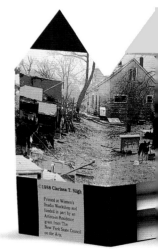

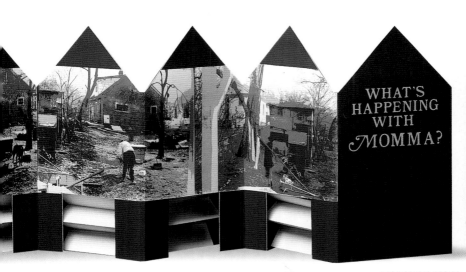

WHAT'S
HAPPENING
WITH
MOMMA?

Gabrielle Fox

WITH JAZZ BY BOBBIE ANN MASON
8½ x 6 x ⁹⁄₁₆ inches (21.5 x 15 x 1.5 cm)

Goatskin, onlays and doublures, silk thread, gold leaf; tooled

PHOTO BY ALICE M. CORNELL

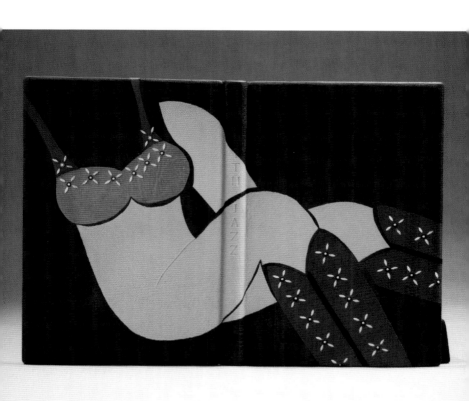

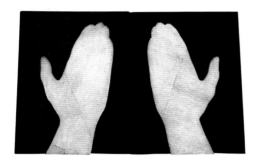

Susan Carol Messer

TERRAIN
8 x 6 x 1 inches (20.3 x 15.2 x 2.5 cm)

Moriki paper, book board, gold leaf;
accordion binding; inlaid, incised

PHOTOS BY ARTIST

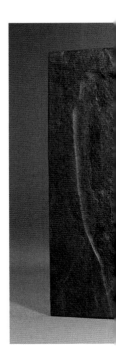

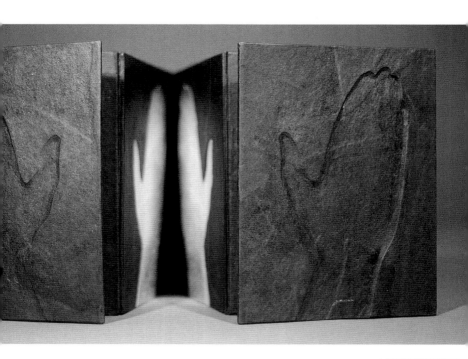

Dayle Doroshow

MIND MAP

2¹/₂ x 3 x 2 inches (6.4 x 7.6 x 5 cm)

Polymer clay, paper; accordion binding;
carved, sculpted, millefiori

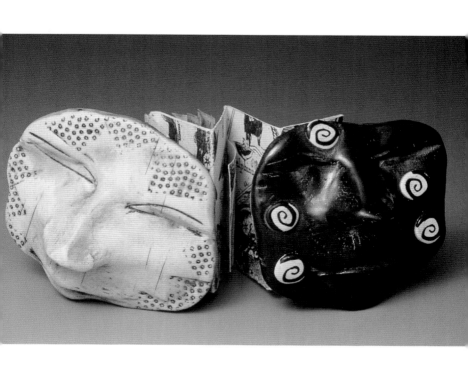

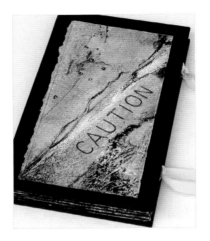

Hanne Niederhausen

CAUTION

Open: 9½ x 13 x 13 inches (24.1 x 33 x 33 cm)
Closed: 9½ x 5 x ¾ inches (24.1 x 12.7 x 1.9 cm)

Rives BFK, Hahnemühle photo matte, Hahnemühle Ingres, ribbons; accordion binding; collagraph printed, inkjet printed, stenciled

PHOTOS BY ARTIST

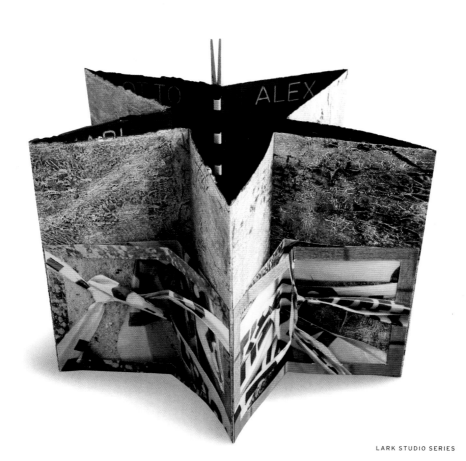

Judith I. Serebrin

WORRY BOOK I

7 x 5 x 1 inches (17.8 x 12.7 x 2.5 cm)

Rives BFK, ink, clear plastic sheeting, paper;
folded monotypes; offset lithography; sewn, etched

PHOTOS BY ARTIST

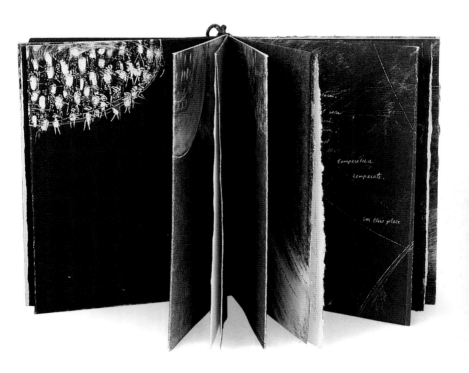

Bettina Pauly

FRAGILE
37 x 16½ inches (94 x 41.9 cm)

Bookcloth, Lokta paper,
cotton ribbon; assembled

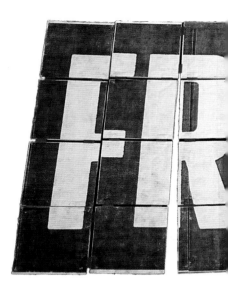

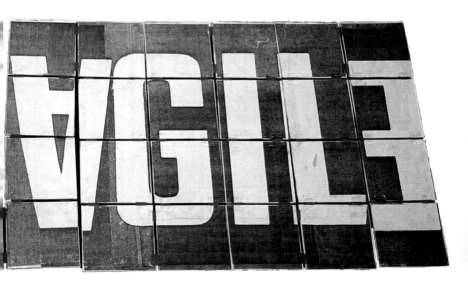

LARK STUDIO SERIES

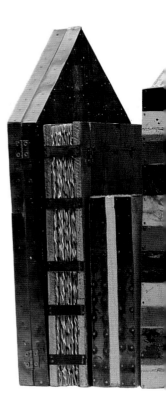

Peter Madden

VARIOUS BINDING EXPERIMENTS
7 x 5 to 18 x 12 inches (17.8 x 12.7 to 45.7 x 30.5 cm)

Slate, copper, wood, cotton, handmade paper;
accordion and Japanese side-sewn variations

PHOTO BY CLEMENTS/HOWCROFT

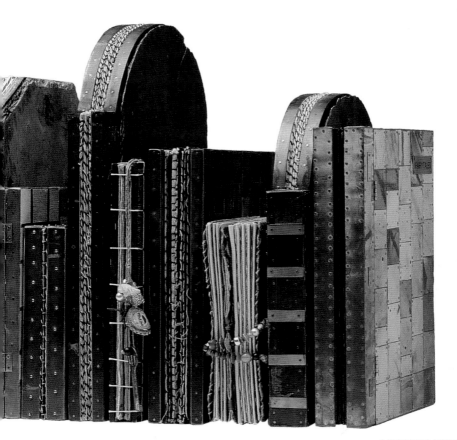

Shu-Ju Wang

NIGHTMARE COMES TRUE
Closed: 5 3/4 x 6 1/4 x 1/2 inches (14.6 x 15.9 x 1.3 cm)

Gouache, Rives BFK, Japanese paper

PHOTO BY ARTIST

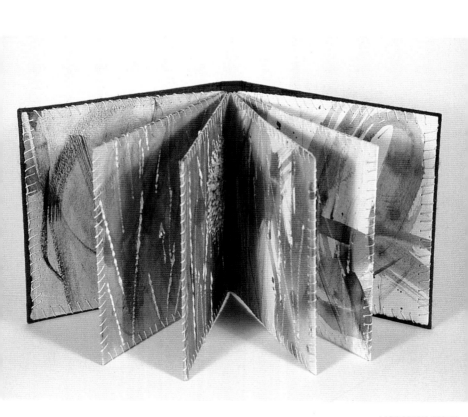

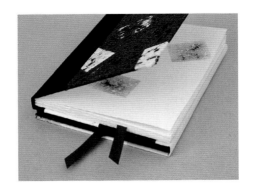

Cathryn Miller

BIPOLAR DREAM JOURNAL #2

7 x 5 x 1½ inches (17.8 x 12.7 x 3.8 cm)

Cloth spine, handmade paper covers and endpapers, Fabriano Ingres textblocks, ribbon, linen thread; dos-a-dos binding

PHOTOS BY DAVID G. MILLER

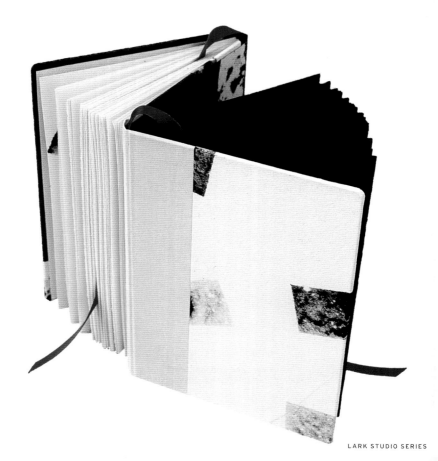

Alice M. Vinson

KEEP OUT

15 x 5 x 1 inches (38.1 x 12.7 x 2.5 cm)

Aluminum wire, steel, aluminum; codex binding,
unique wire binding; black-and-white photographs

PHOTO BY ARTIST

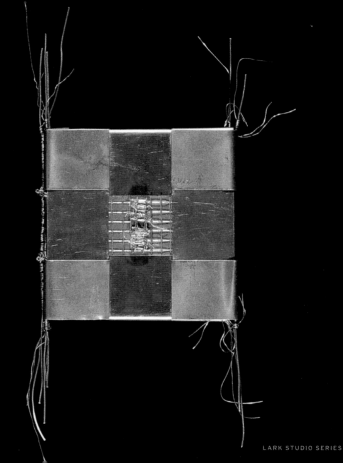

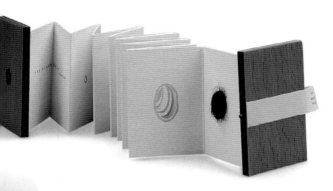

Diane Jacobs

THE BLACK HOLE

3 x 2 x ½ inches (7.6 x 5.1 x 1.3 cm)

Handmade paper, parchment strap, wooden covers,
human hairball; accordion binding; letterpress

PHOTOS BY BILL BACHHUBER

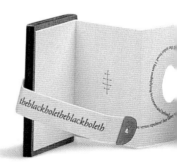

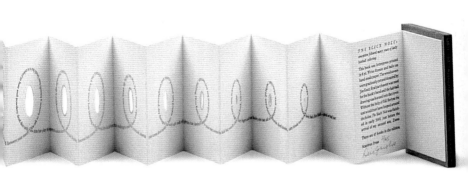

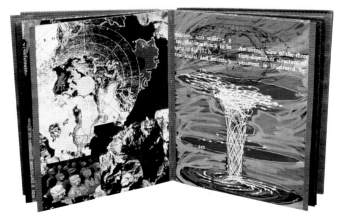

Paula Jull

AND NOW, YOUR LOCAL FORECAST
9 x 10 x ¾ inches (22.9 x 25.4 x 1.9 cm)

Computer circuit boards, handmade paper; inkjet printed

PHOTOS BY ISU PHOTO SERVICES

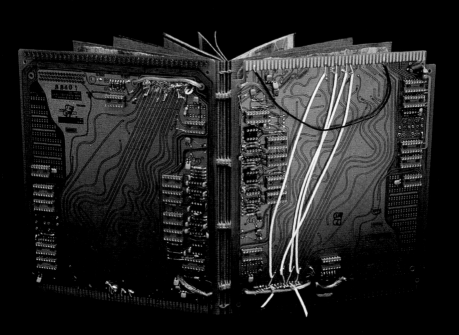

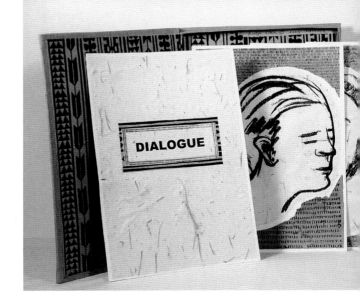

Evelyn Eller

DIALOGUE
13 x 9 x 1 inches (33 x 22.9 x 2.5 cm)

Handmade paper book, Lana and Oriental papers;
mixed media collage, painted, photocopy

PHOTOS BY ARTIST

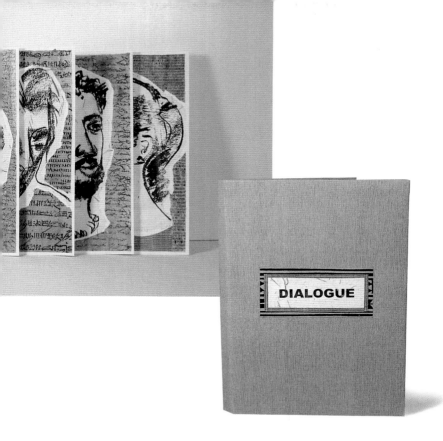

Bonnie Thompson Norman

WORDHOUSE

6¹/₂ x 3¹/₄ x 3¹/₄ inches (16.5 x 8.3 x 8.3 cm)

Chipboard, colored paper, kraft-paper box, waxed
linen thread, ink; edge binding; sewn, letterpress,
colophon, handset types, rubber stamped

PHOTO BY ARTIST

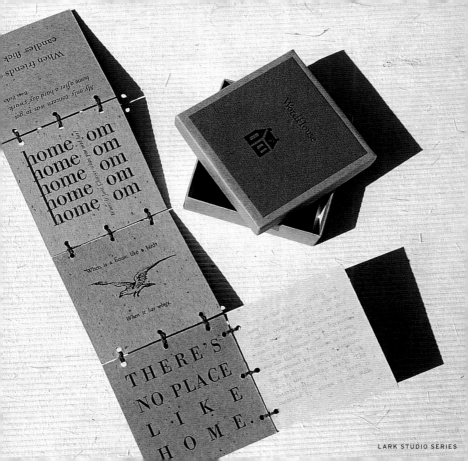

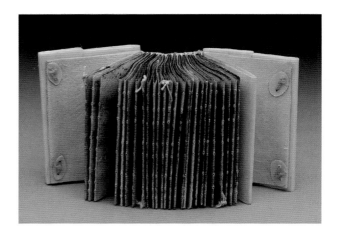

Shanna Leino

DEAR BEN BROWN EYES
2½ x 1¾ x 1½ inches (6.4 x 4.4 x 3.8 cm)

Elk bone, linen thread, flax paper,
sinew, parchment, graphite

PHOTOS BY WALKER MONTGOMERY

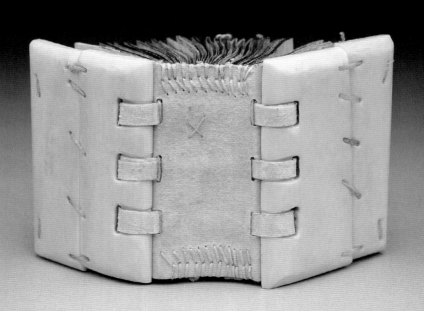

Bridget A. Elmer

THE READER

4 x 4 x 1/8 inches (10.2 x 10.2 x 0.3 cm)

Japanese kozo, handmade paper, waxed linen
thread, organdy cover; double pamphlet-stitch binding;
collograph, chine-collé, letterpress, hand-cut petals

they physically alter the work

Julia Harrison

WRIST BOOK

1½ x 1¼ x ½ inches (3.8 x 3.2 x 1.3 cm)

Leather, cotton paper, matte board, linen
thread, Velcro, Japanese endpapers,
commercial headband, PVA; bound

PHOTO BY KEITH LOBUE

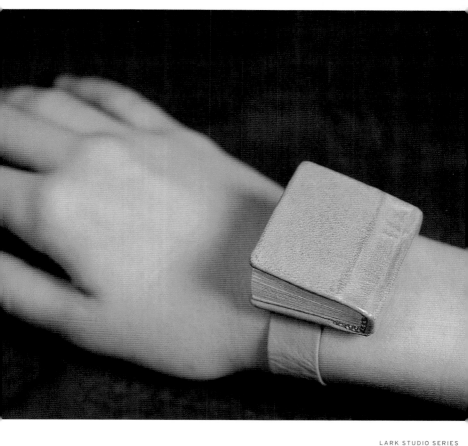

Charles Hobson

THE MAPPIST
11 x 10 x 1¼ inches (27.9 x 25.4 x 3.2 cm)

Prints, transparent film, USGS maps, board;
accordion binding; digital printing

PHOTOS BY ARTIST

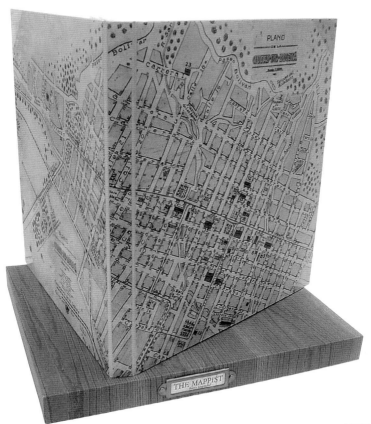

PLANO
DE LA
CIUDAD DE BOGOTÁ

THE MAPPIST

Juliayn Clancy Coleman

MOTION STUDY

7 1/2 x 10 x 2 1/4 inches (19 x 27 x 6 cm)

Paste paper, boards, goatskin, silk chevron
endbands, 23-karat gold; tooling

PHOTO BY SAVERIO TRUGLIA

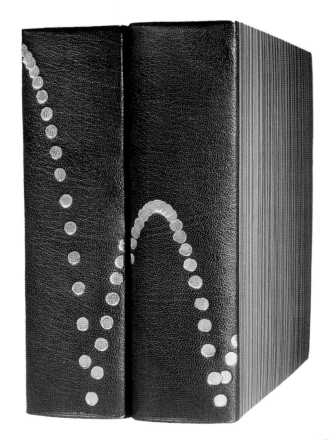

Steve Miller

SKIN BY DAN KAPLAN, TRANSLATED BY MARIA VARGAS

8 x 5 x 1/8 inches (20.3 x 12.7 x 0.3 cm)

Nideggen moldmade text paper, Khadi handmade
paper; letterpress, linocuts, photopolymer plates

PHOTO BY ARTIST
LINOCUTS BY JULIO CESAR PEÑA PERALTA

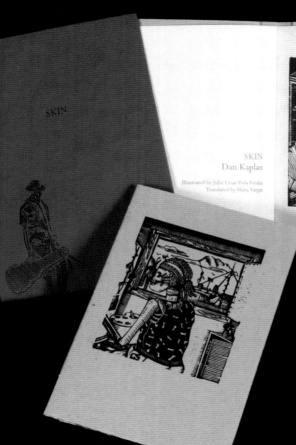

SKIN

SKIN
Dan Kaplan

Illustrated by Julio Cesar Peña Peralta
Translated by Maria Vargas

Red Hydra Press

LARK STUDIO S

Dorothy A. Yule

DOYLE THE LOYAL ROYAL

Book: 2 3/4 x 2 13/16 x 1 3/8 inches (7 x 7.3 x 3.4 cm)
Box: 3 7/8 x 3 7/8 x 2 1/2 inches (9.8 x 9.8 x 6.4 cm)

Mohawk Superfine, museum boards, tulle, cellophane, clear plastic
sheeting; tunnel book, rotating wheel, pulley tabs; laser printed

PHOTO BY ARTIST

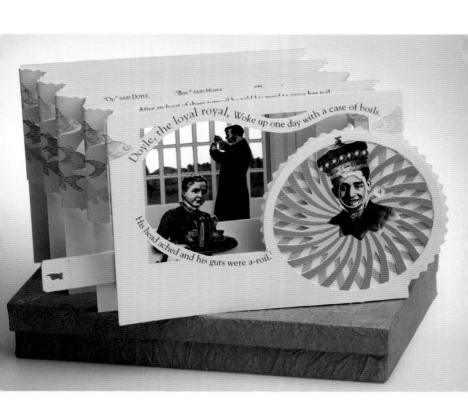

"Oy," SAID DOYLE. "Bov," SAID HOWE.

After an hour of sheer turmoil he told his maid to cease her toil.

Doyle, the loyal royal, Woke up one day with a case of boils.

His head ached and his guts were a-roil.

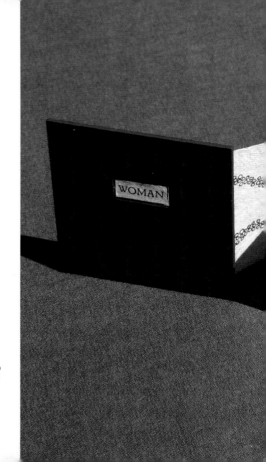

Katrin Kapp Braun

WOMAN

$2^{15}/_{16}$ x $2^{15}/_{16}$ x $1^{3}/_{16}$ inches (7.5 x 7.5 x 3 cm)

Cotton abaca paper, Hahnemühle Biblio paper; accordion binding; letterpress

PHOTO BY ARTIST

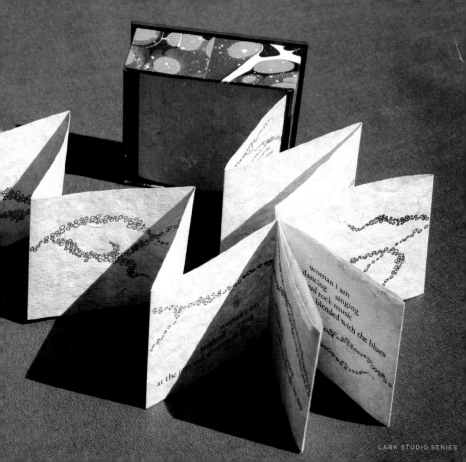

woman i am
dancing singing
...ud rock music
blended with the blues

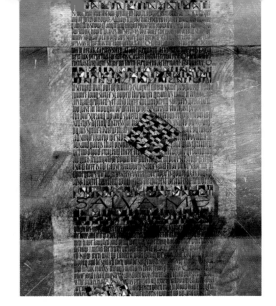

Jan Owen

DIES IRAE

46 x 15½ inches (116.8 x 39.4 cm)

Paper, acrylic, Sumi ink, Tyvek; accordion binding; painted, woven

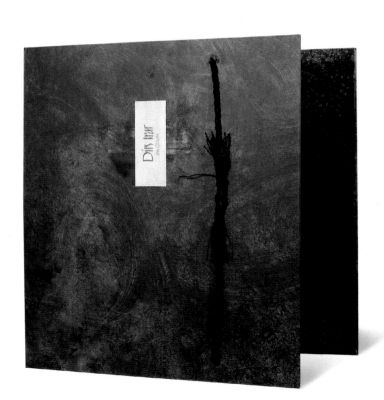

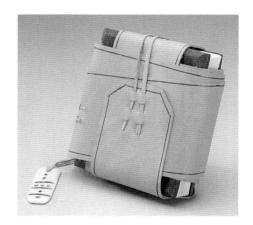

Marie C. Oedel

LEATHER CROSSBOOK
5¼ x 4¾ x 1½ inches (13.5 x 12 x 4 cm)

Mohawk vellum, linen thread, leather, wood;
multi-quire Coptic codex; sewn, carbon tooled

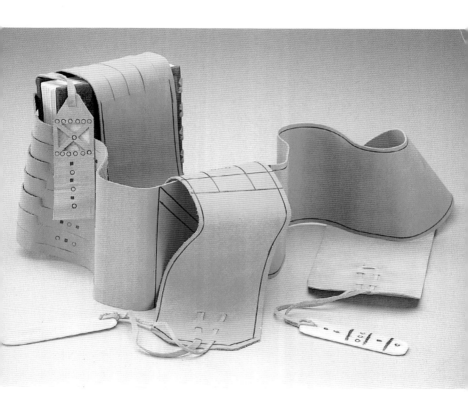

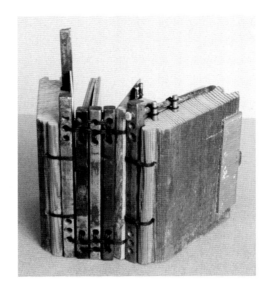

Susan Collard

LYRIC INVENTION NO. 1

5 x 3½ x 3 inches (12.7 x 8.9 x 7.6 cm)

Board book, birch aircraft plywood, oak, reclaimed tongue-and-groove
 fir covers, metal, brass, waxed linen thread, paper, hardware;
 tied, mixed-media collage, handwritten text

PHOTOS BY ARTIST

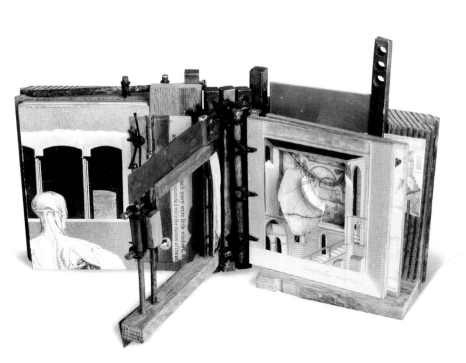

Michelle Francis

DOS-A-DOS TIMES TWO
4¹/₈ x 3³/₈ x 3 inches (10.5 x 8.6 x 7.6 cm)

Flax, speckle tone, waxed linen thread;
Coptic, tacket, and long-stitch bindings

PHOTO BY TOM MILLS

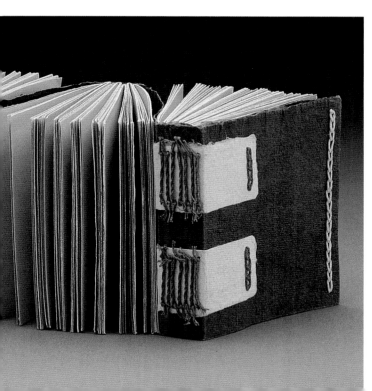

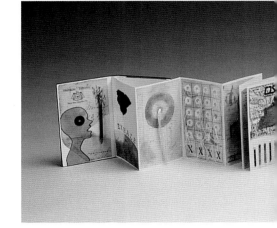

Mar Goman

EXHALE

5$\frac{1}{2}$ x 3$\frac{1}{2}$ x 2 inches (14 x 8.9 x 5 cm)

Altered Moleskine notebook; Japanese-style binding;
mixed media, collage, sewn, drawn, painted, transfer

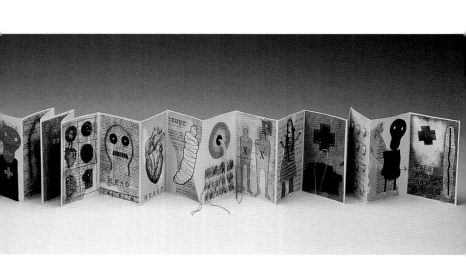

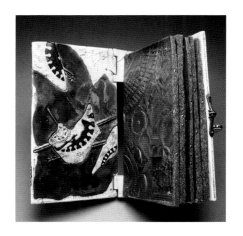

Robert Dancik

MAPS, MARKERS, AND THE TERRITORY
9 x 5 x 3 inches (22.9 x 12.7 x 7.6 cm)

Felt, copper, Faux Bone, polymer clay, brass box hinges, sterling silver wire, compass, paint, graphite, shoe polish, steel; stamped, scratched, burned, embossed, die formed

PHOTOS BY DOUGLAS FOULKE

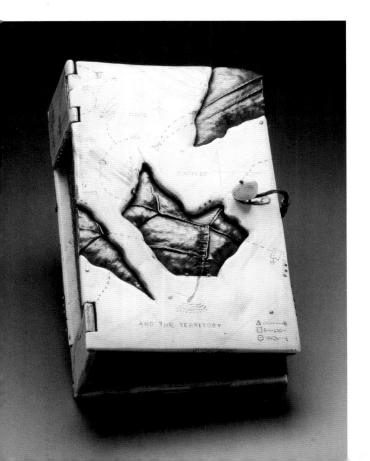

Lynn Sures

VARIATIONS ON THE DIALECTIC BETWEEN
MINGUS AND PITHECANTHROPUS ERECTUS

Closed: 10½ x 7½ x ½ inches (26.7 x 19 x 1.3 cm)
Open: 10½ x 60 inches (26.7 x 152.4 cm)

Abaca, hemp, linen thread, handmade paper; accordion
binding and sewn-in pamphlet bindings; pulp painted,
watermarked, letterpress, woodcut

PHOTO BY PRS ASSOCIATES

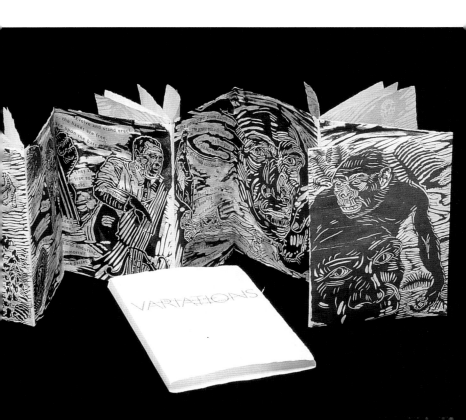

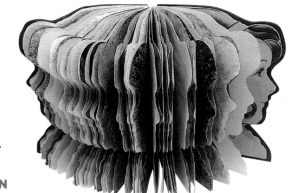

Crystal Cawley

STONE WOMEN
10 x 8 x 3 inches (25.4 x 20.3 x 7.6 cm)

Old storybook pages, acrylic, various papers,
mica dust, wood; Coptic binding

PHOTOS BY JAY YORK

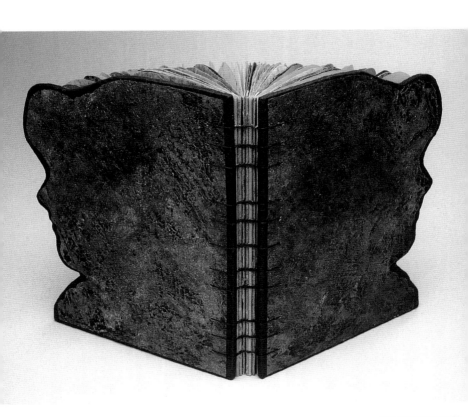

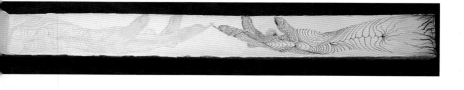

Ana Garcés Kiley

DEBAJO DE LA CAMA
3 x 30 x 1 inches (7.6 x 76.2 x 2.5 cm)

Arches paper, watercolor, ink; machine-screw binding

PHOTOS BY ARTIST

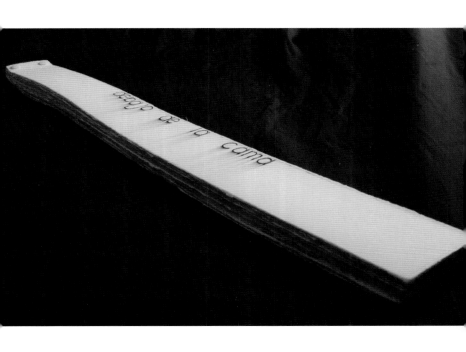

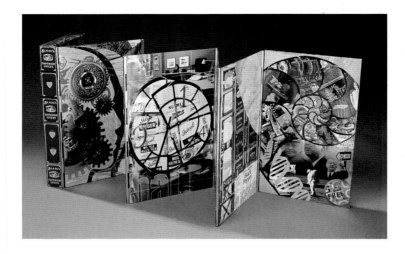

Harriete Estel Berman

AND THERE WAS LIGHT

14 1/4 x 9 x 3 inches (36.2 x 22.9 x 7.6 cm)

Reclaimed tin containers, vintage steel dollhouses, 10-karat gold and
aluminum rivets, brass hinge pins, stainless steel screws, acrylic inks,
gesso, hand-fabricated metal hinges; accordion binding; riveted

PHOTOS BY PHILIP COHEN

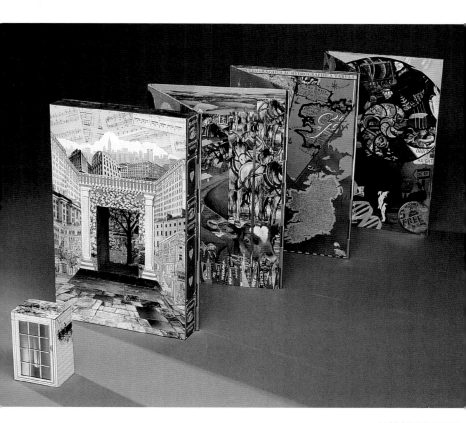

Cathy Adelman

ZEICHNUNGEN PAUL KLEE

9½ x 6¼ x ¹⁵/₁₆ inches (24.1 x 15.9 x 1 cm)

Leather, onlays; three-piece binding; blind tooling

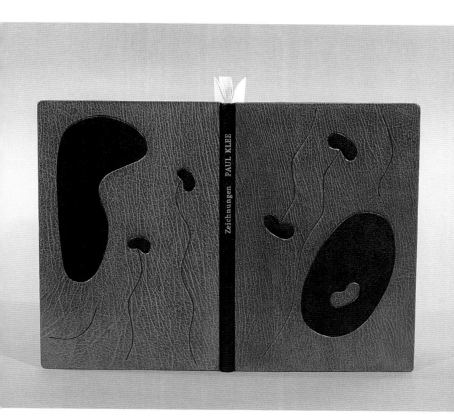

Zeichnungen PAUL KLEE

Cary Loving

CLOSED CHAPTER
8 x 4 x 10 inches (20.3 x 10.2 x 25.4 cm)

Clay, glaze, recycled book pages, cord

PHOTO BY TAYLOR DABNEY

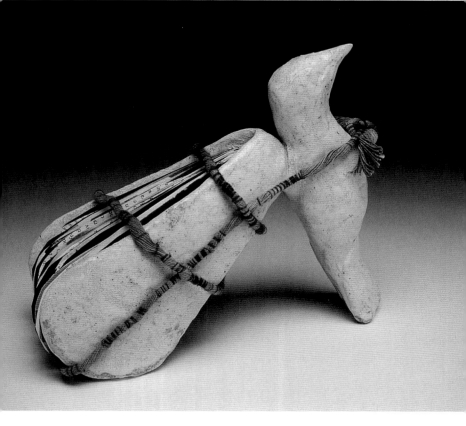

Karen J. Lauseng

UNTITLED
4¹/₂ x 3 x 5 inches (11.4 x 7.6 x 12.7 cm)

Colored toothpicks, seed beads, used coffee
filters, dowel rod, wooden block; piano hinge

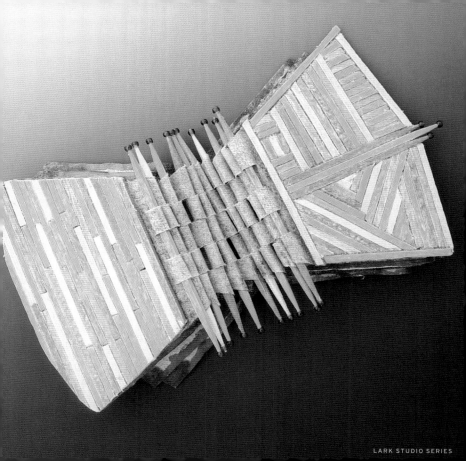

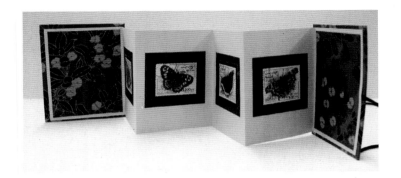

Kathryn Rodenbach

AFGHAN POST BUTTERFLIES

4³⁄₈ x 20 x ³⁄₈ inches (11 x 50.8 x 0.9 cm)

Japanese paper, matte board, pastel paper, mulberry paper, metal embellishment, Afghan stamps, ribbon; accordion binding; collaged

PHOTOS BY CARRIE CLAYCOMB

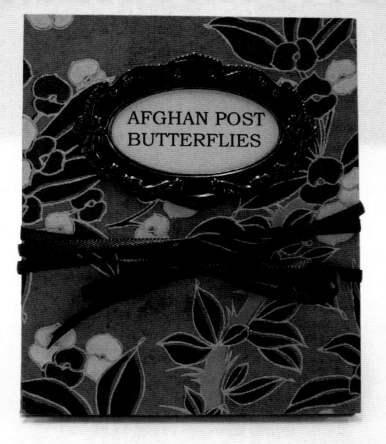

AFGHAN POST
BUTTERFLIES

Susan Kapuscinski Gaylord

SPIRIT BOOK #30: IXCHEL'S DREAM
5¹/₂ x 12 x 11¹/₂ inches (14 x 30.5 x 29.2 cm)

Mexican amatyl paper, banana mesquite paper, horn beads,
wood beads, thread, coconut shells, corn, binders board

PHOTO BY DEAN POWELL

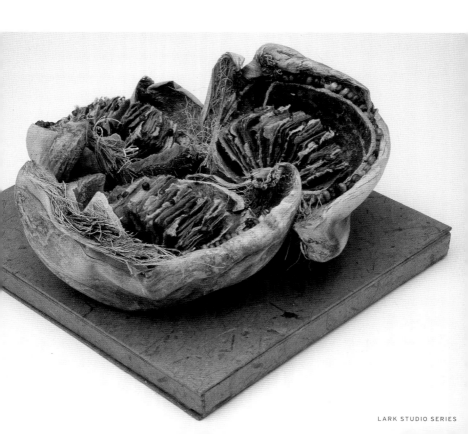

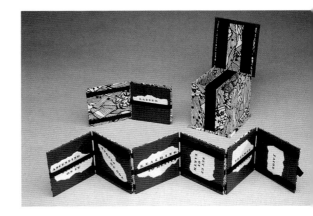

Joy M. Campbell

3 IN 1 JACOB'S LADDER

4¹/₂ x 3³/₄ x 4¹/₂ inches (11.4 x 9.5 x 11.4 cm)

Book board, Japanese paper, grosgrain ribbons, bead, laminated cards, ladder, trick book; Jacob's Ladder construction for box; computer-generated text

PHOTOS BY JAMES HART

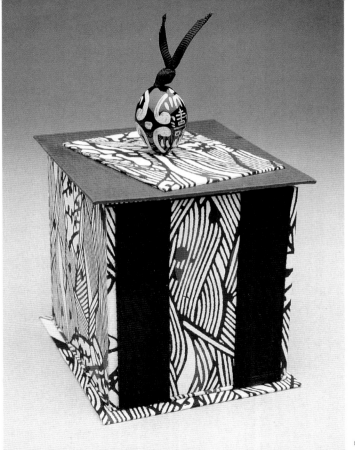

Beata Wehr

ZESZYT O CZASIE (ON TIME)

10 x 8$\frac{1}{2}$ x $\frac{3}{4}$ inches (25.4 x 21.6 x 1.9 cm)

Linen, gesso, metal objects, linen thread, ink

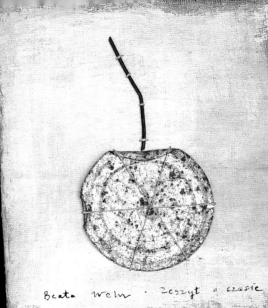

Beata Wehr · Zeszyt o czasie

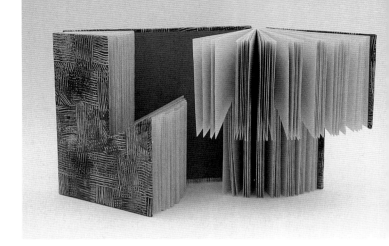

Ingrid Hein Borch

UNTITLED

$5^{7}/_{8}$ x $7^{1}/_{16}$ x $^{3}/_{4}$ inches (14.9 x 18 x 1.9 cm)

Book board, paste paper, dyed linen thread,
acid-free text paper; Coptic binding

PHOTOS BY ALBERT J. BORCH

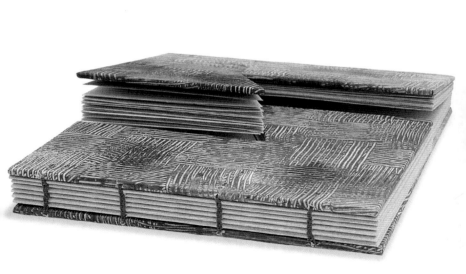

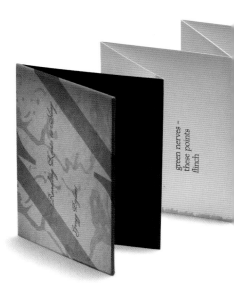

Kyle Schlesinger

READING KEATS TO SLEEP
BY GREGG BIGLIERI

4¹⁄₈ x 5¹⁄₈ x ³⁄₈ inches (10.5 x 13 x 1 cm)

Binders board, Fabriano paper, acrylic ink, colored pencils, multiple printer inks, archival glue; accordion binding; letterpress, painted, hand colored

PHOTO BY BILL HENRICH

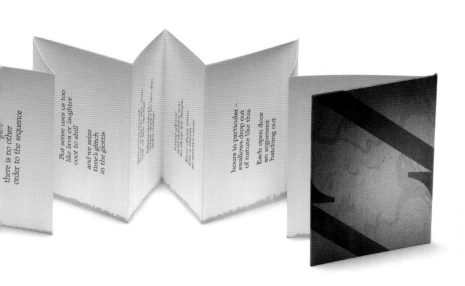

there is no other
order to the sequence

But sense uses us too
like lava or laughter
coot to shill

and we seize
time's glitch
in the glottis

hours in particular –
swallows drop out
of nature like this.

Each open door
an argument
hatching out

Marilyn R. Rosenberg

ACCEPT/DECLINE
6 x 3⅜ inches (15.2 x 8.5 cm)

Paper, gouache, ink; post binding; stenciled

PHOTO BY ARTIST

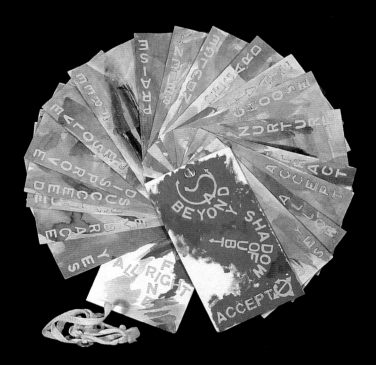

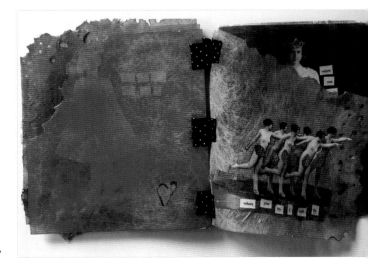

Lesley Riley

FOLLOW
9 x 9 x 1 inches (22.9 x 22.9 x 2.5 cm)

Lutradur, acrylics, fabrics, trims, vintage apparel, fusible
 interfacing, beads; sewn tab bindings; etched, machine stitched

PHOTOS BY ARTIST

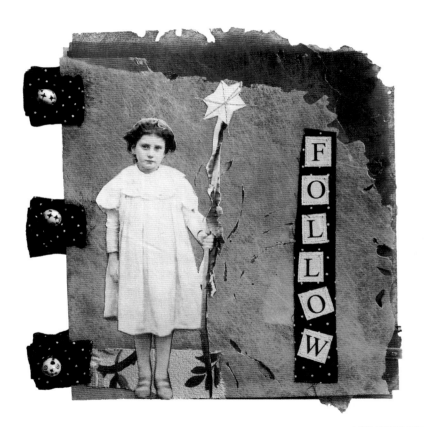

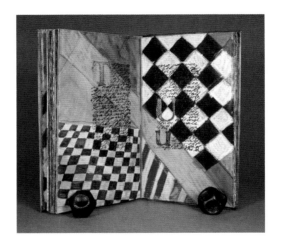

Laura Wait

THE OTHER GODDESS IN THE GARDEN
10½ x 5¾ x ¾ inches (26.7 x 14.6 x 1.9 cm)

Arches cover paper, Mylar, leather, wood, parchment,
acrylic paint, artist's pens; modified simple binding,
exposed sewing on concertina; painted, handwritten

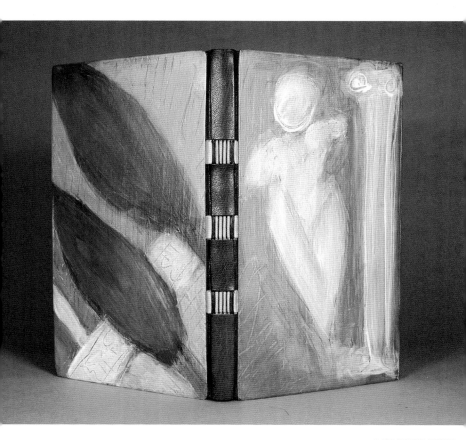

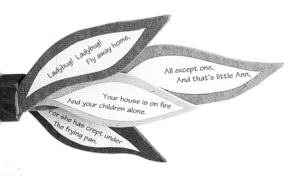

Ladybug! Ladybug! Fly away home,

All except one,
And that's little Ann,

Your house is on fire
And your children alone.

For she has crept under
The frying pan.

Stephanie Dean-Moore

LADYBUG, LADYBUG

6 x 13½ x 1 inches (15.2 x 34.3 x 2.5 cm)

Japanese papers, marbled papers, linen thread, brass
sheet, black onyx beads; altered Coptic binding, sculpted
binding; pierced metal, riveted, inkjet printed

PHOTOS BY JULIAN BEVERIDGE

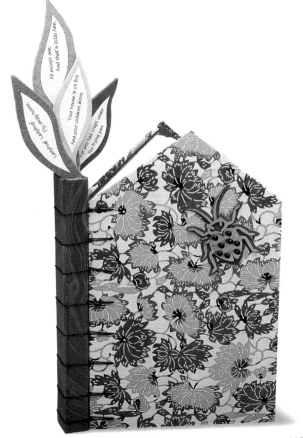

Ladybug! Ladybug! Fly away home,
For she has crept under
The frying pan.
And your children alone.
Your house is on fire
All except one, And that's little Ann.

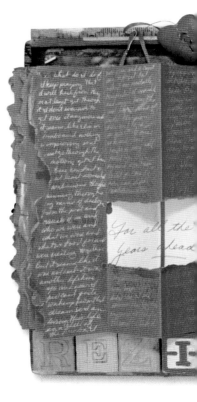

Laura Ann Morris

REZIDU

12 x 17 1/2 x 3 inches (30.5 x 44.5 x 7.6 cm)

Wooden cigar box, blocks, roses, paint, found objects;
star fold, accordion fold, foldout tabs, tear-outs

PHOTO BY KRISTI FOSTER

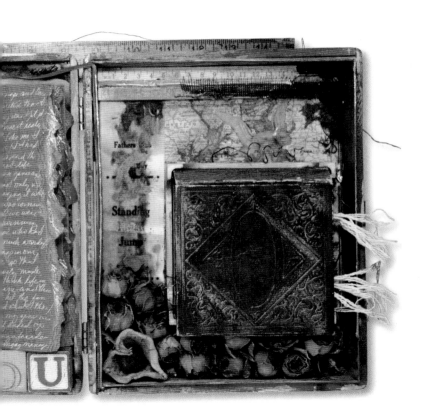

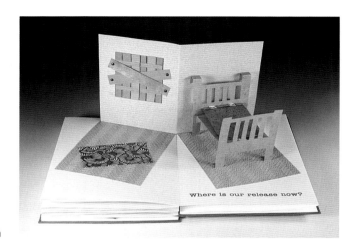

Where is our release now?

Emily Martin

SLEEPERS, DREAMERS, AND SCREAMERS

9¹/₂ x 7 x 2 inches (24.1 x 17.8 x 5 cm)

Gampi, cotton, and assorted papers;
accordion binding, pop-up; letterpress

PHOTOS BY MERYL MAREK

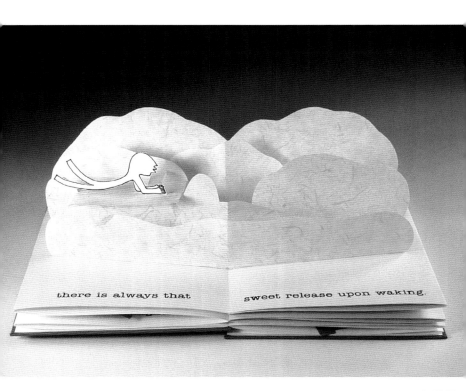

there is always that　　　sweet release upon waking.

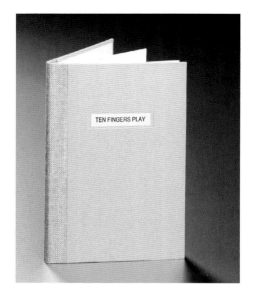

Stephanie Wolff

TEN FINGERS PLAY

6 3/16 x 4 3/16 x 5/16 inches (15.7 x 10.7 x 0.8 cm)

Paper, bookcloth, binders board; concertina codex; color and laser copy

PHOTOS BY JOHN SHERMAN

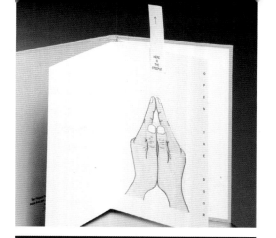

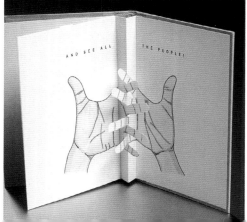

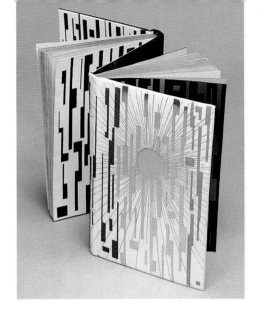

Monique Lallier

THE PILGRIM'S PROGRESS BY JOHN BUNYAN

7½ x 5 x ¾ inches (19 x 12.7 x 1.9 cm)

Morocco leather, onlays; dos-a-dos binding; embroidered, tooled, gilded

PHOTOS BY TIM BARKLEY

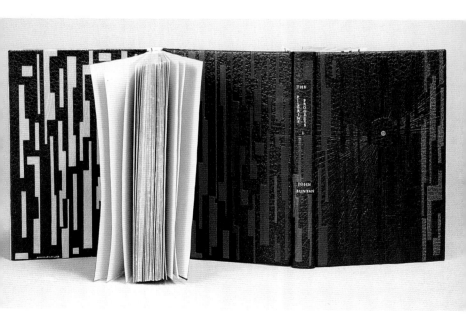

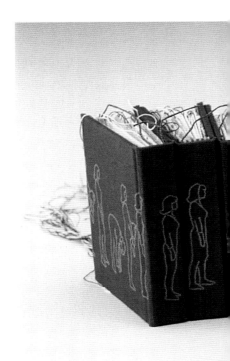

Julia Elsas

CIRCULATORY ACTIVITIES

Each: 3¹/₈ x 3¹/₈ x ⁵/₈ inches (7.9 x 7.9 x 1.6 cm)

Wallpaper, thread, cloth, board; case
bound; silkscreen; machine sewn

PHOTO BY NCMA

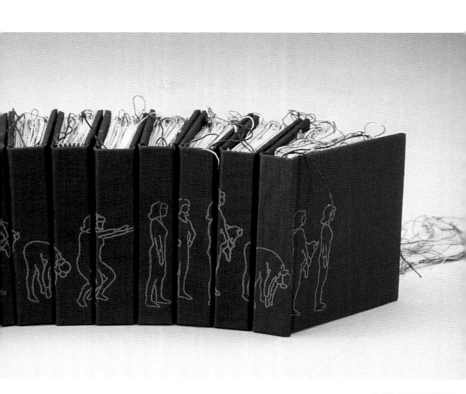

Alicia Bailey

ANTROPA MANDRAGORA

Closed: 10 x 4 x 1 inches (25.4 x 10.2 x 2.5 cm)

Glue chip glass; Coptic single-sheet
binding; stained, painted, fired

PHOTO BY ARTIST

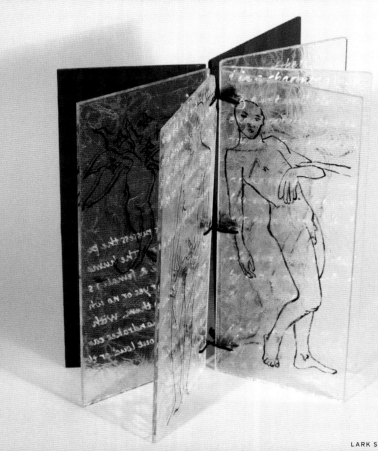

Julie L. Johnson

ALETA

6½ x 5 x 1 inches (16.5 x 12.7 x 2.5 cm)

Handmade sisal, gampi, kozo, and papyrus papers, artist's black
and white photographs, linen, cedar bark, dock, crocosmia;
dos-a-dos binding; Keith Smith side-bow spine stitching

PHOTOS BY BRUCE MCCAMMON

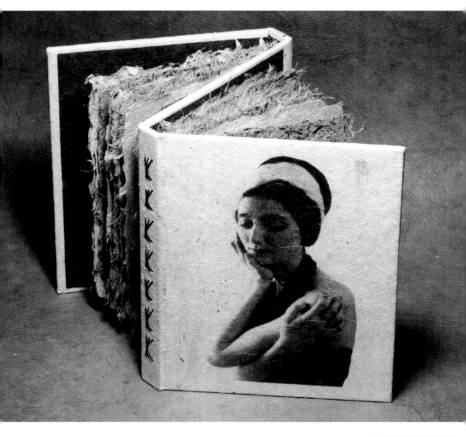

Jeanne Germani

WINGS

2¹/₂ x 3¹/₂ x 1³/₄ inches (6.4 x 8.9 x 4.4 cm)

Stonehenge paper, found paper, balsa wood, wings, antique necklace parts, metal cross and bird, thread; accordion flutter binding; collage, decorative stitching, photo transfer, blender pen transfer

PHOTO BY DAVID BRIGGS

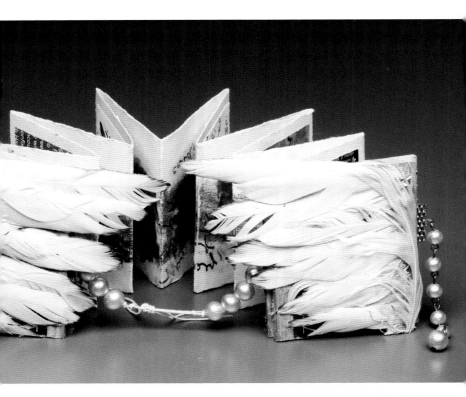

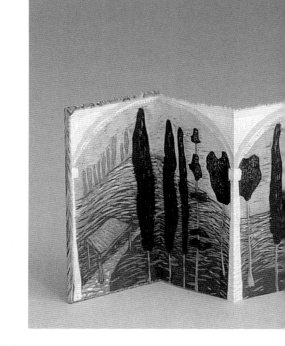

Jenni Freidman

FINDING FLORENCE

5¹/₂ x 3³/₄ x ¹/₄ inches (14 x 9.5 x 0.6 cm)

Japanese paper, Italian hand-marbled paper;
accordion binding; letterpress, woodcut

PHOTO BY LARRY GAWEL

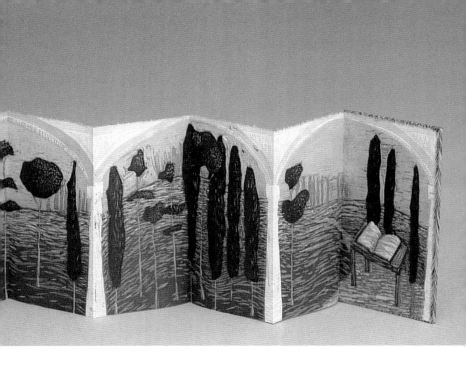

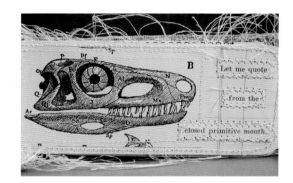

Lisa Kokin

THE ORIGIN OF BIRDS

5½ x 2½ x 1 inches (14 x 6.4 x 2.5 cm)

Book spines, found text and images,
thread; machine stitched

PHOTOS BY JOHN WILSON WHITE

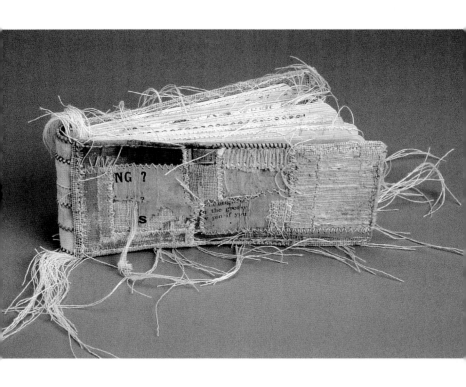

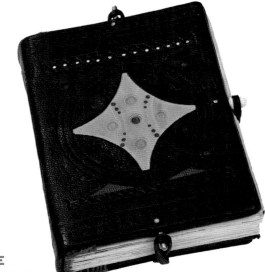

Bea Nettles

DEER ISLE, MAINE
5 x 3¾ x 1¼ inches (12.7 x 9.5 x 3.2 cm)

Leather, papyrus, artist paper, linen thread, colored pencil,
walnut ink, brass pegs; Coptic binding; etched, cyanotype,
silver gelatin prints, handwritten text, hand-carved bone

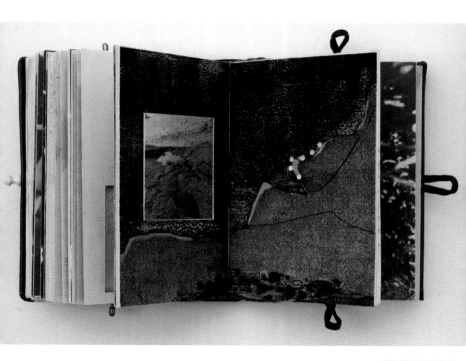

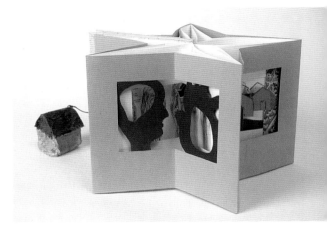

Emily Gold

THESE WALLS
Closed: 6¼ x 5½ inches (15.9 x 14 cm)

Canson and Mohawk superfine papers, handmade
paper; carousel book; collage, hand stitched

PHOTOS BY STEVEN TRUBITT

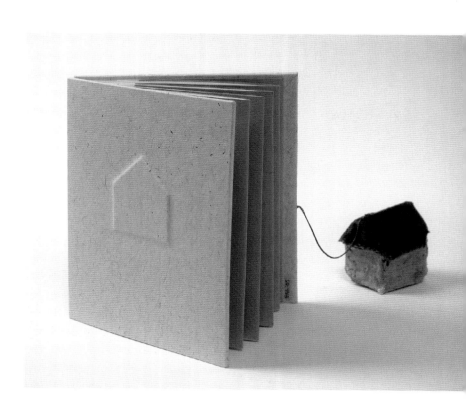

Val Lucas

PLANS D'AIX
5 x 5 x 3 inches (12.7 x 12.7 x 7.6 cm)

Watercolor and pen on Fabriano cold
press; accordion binding, sewn

PHOTO BY ARTIST

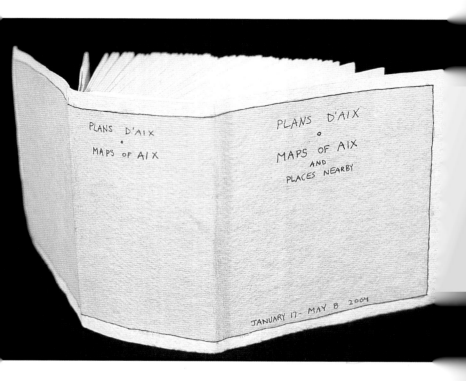

PLANS D'AIX

MAPS OF AIX

PLANS D'AIX

MAPS OF AIX
AND
PLACES NEARBY

JANUARY 17 - MAY 8 2004

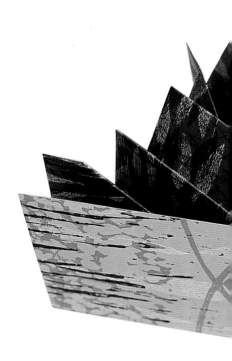

Alice Austin

RED, YELLOW, BLUE
10 x 5 x 3 inches (25.4 x 12.7 x 7.6 cm)

Paste paper; map fold; offset lithography

PHOTO BY ARTIST

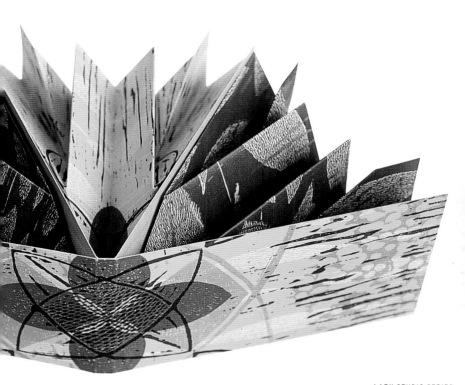

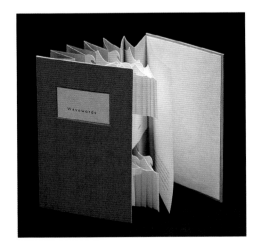

Margery S. Hellmann

WAVEWORDS
Closed: 7 3/4 x 4 5/8 x 1/2 inches (19.7 x 11.8 x 1.3 cm)

Rives BFK, UV ultra, Strathmore 500 papers; paper over boards
binding; flag book, die cut; letterpress, handset type, suminagashi

PHOTOS BY ARTIST

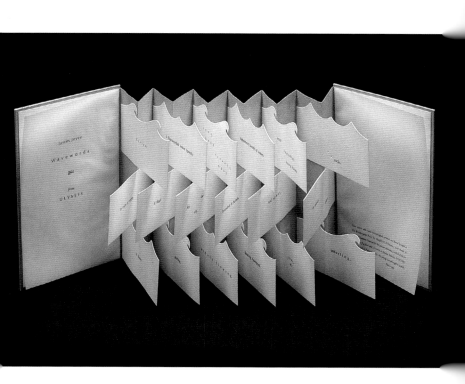

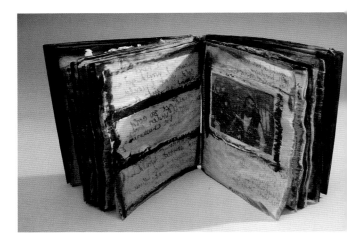

Katherine Rhodes Fields

IS BLOOD THICKER THAN WATER?

5¼ x 4¾ x 1¼ inches (13.3 x 12.1 x 3.2 cm)

Resin-coated photo paper, vellum, crochet thread, PVA glue, acrylic paint,
skins; buttonhole stitching; silver gelatin; ink drawings and text

PHOTOS BY ARTIST

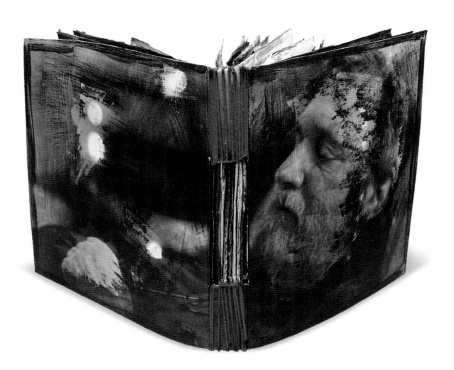

Jackie Niemi

EVOLUTION

5 x 6¹/₄ x 1 inches (12.7 x 15.9 x 2.5 cm)

Paper, linen thread, plant materials, walnut and oak gall
inks, clay pigment, foam core, museum board; tacket
binding; collage, stitched, stamped, written, painted

PHOTO BY ARTIST

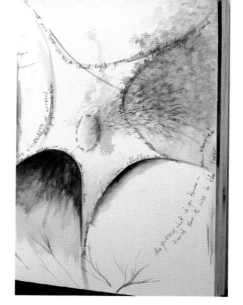

Mindy Belloff

TEN REFLECTIONS ON RAINER MARIA RILKE'S DUINO ELEGIES

10 1/2 x 7 1/2 x 3/8 inches (26.7 x 19 x 1 cm)

Original gouache, pigment and ink paintings, archival rag paper; binding by Judith Ivry; digital printing, hand painted, collage

PHOTOS BY ARTIST

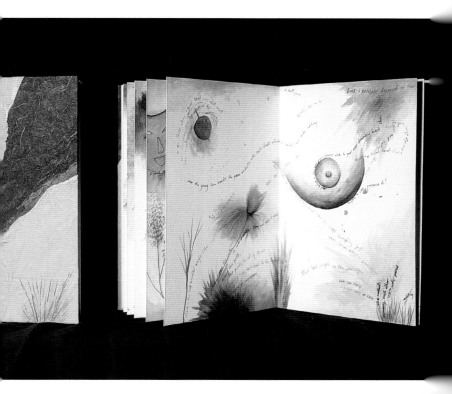

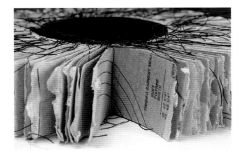

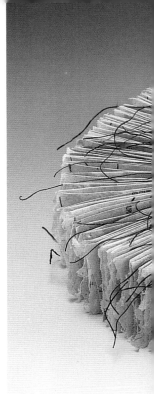

Erica Spitzer Rasmussen

COLLAR #2: BOOK OF MEASURES

2 x 10 x 10 inches (5 x 25.4 x 25.4 cm)

Cotton, flax, dress pattern paper, matte medium,
waxed linen thread, Velcro; pamphlet stitched

PHOTOS BY PETRONELLA YTSMA

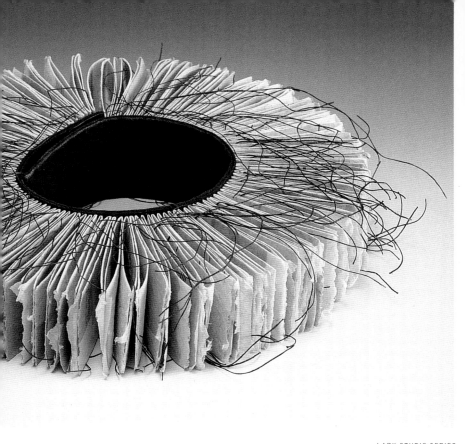

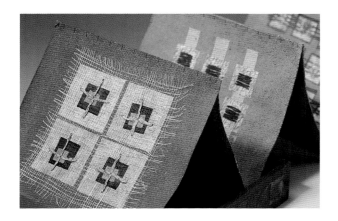

Nancy Pobanz

GRIDLOCK

7³/₄ x 6¹/₂ x 1³/₄ inches (19.7 x 16.5 x 4.4 cm)

Handmade paper, abaca cloth, canvas, acrylic inks, earth
pigments, graphite, painted and waxed linen threads; accordion
binding; painted, collage, handwritten, pen and ink

PHOTOS BY LIGHTWORKS PHOTOGRAPHY

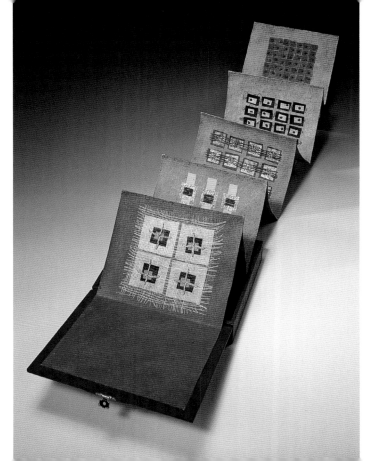

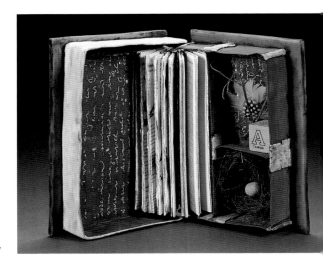

Geraldine A. Newfry

HOMAGE TO AUDUBON
9 x 6 x 2 inches (22.9 x 15.2 x 5 cm)

Polymer clay, found objects, copper, branches, feathers, child's
block; Coptic binding; hand etched, liquid polymer sgraffito

PHOTOS BY LARRY SANDERS

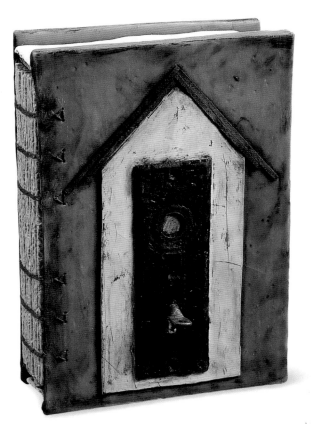

e Bond

FAULT LINES

7 1/8 x 7 1/8 x 3/4 inches (18.1 x 18.1 x 1.9 cm)

Handmade paper; caterpillar binding; recycled
metal pieces, linen and metallic thread

PHOTOS BY SIOBHAN EDMONDS

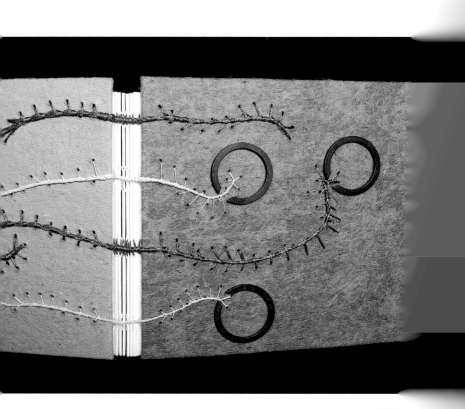

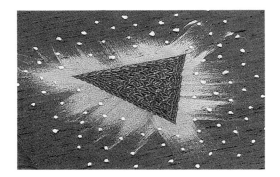

Charlotte Bird

STITCHED MEDITATIONS
10 x 10½ x 1 inches (25.4 x 26.7 x 2.5 cm)

Silk dupioni, interfacing, cotton, metallic and linen thread, binder board, textile paint, silk frog; machine sewn, silkscreened, embroidered

PHOTOS BY JACK YONN

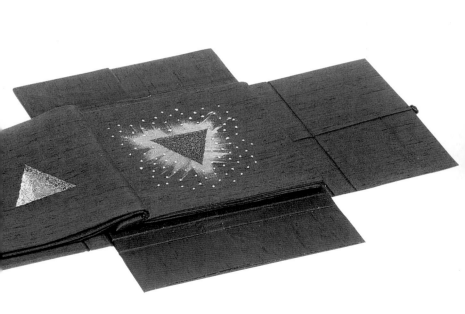

Deena Schnitman

UNTITLED

6 1/2 x 5 x 1 1/2 inches (16.5 x 12.7 x 3.8 cm)

Handmade paste paper, acid-free textblock, bookcloth, waxed linen; buttonhole stitched

PHOTO BY JEFF BAIRD

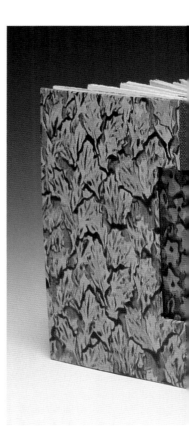

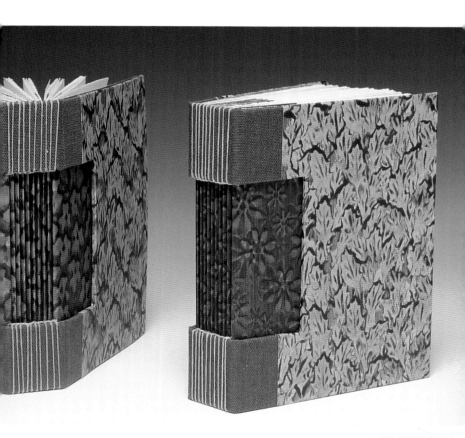

Mary Ellen Long

PAGINGS
6 x 5½ x 5 inches (15.2 x 14 x 12.7 cm)

Arches paper, copper, nature-altered book pages, linen thread; accordion binding, running stitch attachment; hand stamped, collage

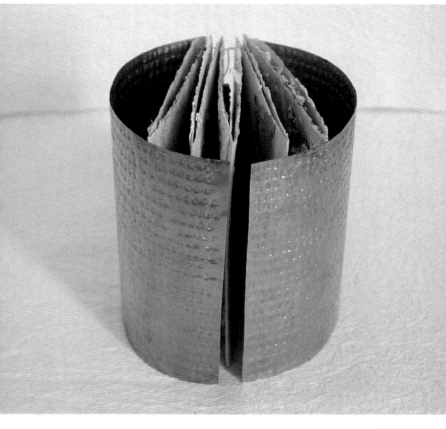

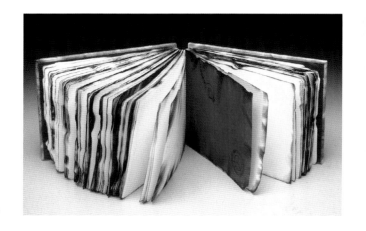

Erin B. Gray

CEREOLOGY II
5¼ x 7¼ x 1 inches (13.3 x 18.4 x 2.5 cm)

Copper, lead-free enamel, handmade paper, waxed linen, ink, wood,
Limoges enamel; Coptic binding; drawn, painted, smoked edges

PHOTOS BY TIM BARNWELL

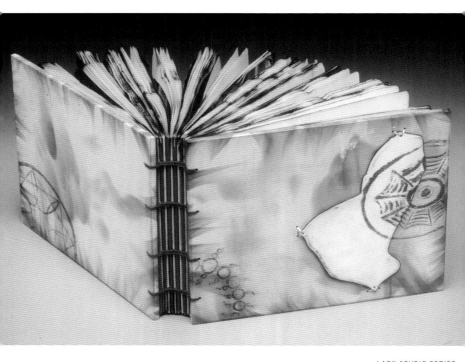

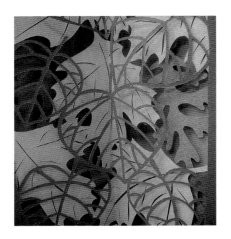

Teresa Childers

FALLING LEAVES: A STAR BOOK

8 x 3⅜ x 1½ inches (20.3 x 8.6 x 3.8 cm)

Canson Mi-Teintes paper, book board, ribbon,
embroidery floss; star book binding; hand cut

PHOTOS BY ARTIST

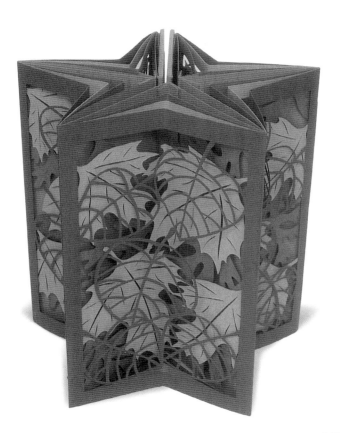

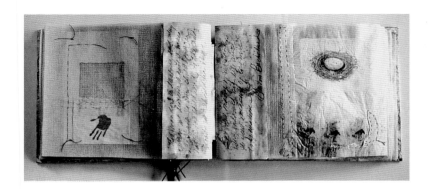

Sandy Webster

ARTIST RETREAT BOOK

8 x 10 x 2 inches (20.3 x 25.4 x 5 cm)

Altered papers, cloth, paint, graphite, found objects; double
paged, long stitch; painted, written, stitched, tied

PHOTOS BY ARTIST

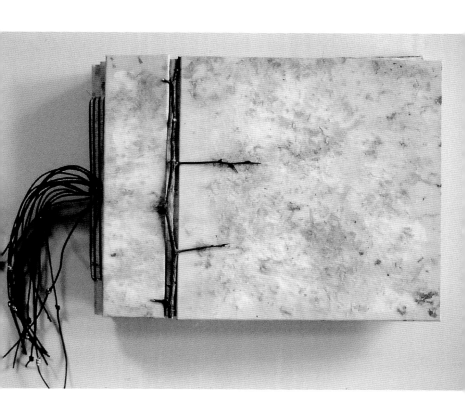

Jody Alexander

THE FLIGHT OF MRS. VIOLA D. PIGEON

6 x 4$\frac{1}{2}$ x 1$\frac{1}{2}$ inches (15.2 x 11.4 x 3.8 cm)

Kozo and gampi blend paper; encaustic;
 packed sewing over split thongs binding

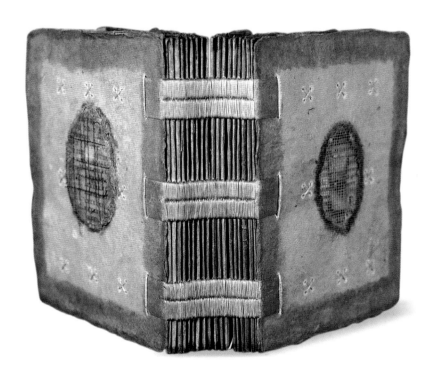

Harry Reese

FUNAGAINSTAWAKE
12¼ x 9¼ x 1 inches (31.1 x 23.5 x 2.5 cm)

Magnani's Italia paper; wire-edge binding; monotype prints from hand-painted vinyl, letterpress, handset type, photo engraving, polymer plates

PHOTOS BY DOUG FARRELL

(Bababadalgharaghtakamminarronnkonnbronntonnerronntuonnthunntrovarrhounawnskawntoohoohoordenenthurnuk!)(perkodhuskurunbarggruauyagokgorlayorgromgremmitghundhurthrumathunaradidillifaititillibumullunukkunun!)(klikkaklakkaklaskaklopatzklatschabattacreppycrottygraddaghsemmihsammihnouithappluddyappladdypkonpkot!)Bladyughfoulmoecklenburgwhurawhorascortastrumpapornanennykocksapastippatappatupperstripputtanach, eh?Thingcrooklyexineverypasturesixdixlikencehimaroundhersthemaggerbykinkinkankanwithdownmindlookingatedrunagainstawakelukkedoerenduardurraskewdylooshoofermoyportertooryzooysphalnaborrtansporthaokansakroidverjkapakkapuk.sothallchoractorschumminaroundgansumuminarumdrumstrumtruminahumptadumpwaultopoofooolooderamaunsturnup!Pappappapparrassannuaragheallachnatullaghmonganmacmacmacwhackfalltherdebblenonthedubblandaddydoodled(hussstenhammerstencaffincoffintussemtossemdamandamnacosaghcusaghhobixhatouxpeswchbechoscashlcarcarcaract.)Ullhodturdenweirmudgaardgringnirurdrmolnirfenrir!lukkilokkibaugimanddddrrrrinsurtkrinmgernrackinarockar!Thor'sforyou!

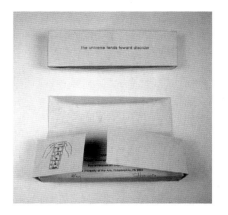

Susan T. Viguers

THE UNIVERSE TENDS TOWARD DISORDER

Open: 11 x 6 1/2 x 3/16 inches (27.9 x 16.5 x 0.5 cm)

Reclaimed wood shutters, Tyvek, Elephant Hide paper;
Jacob's Ladder structure; letterpress, screen printed

PHOTOS BY ARTIST

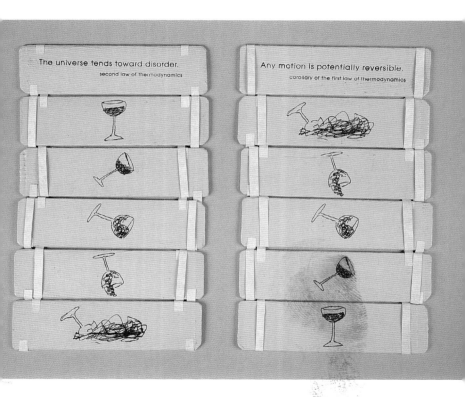

The universe tends toward disorder.

second law of thermodynamics

Any motion is potentially reversible.

corollary of the first law of thermodynamics

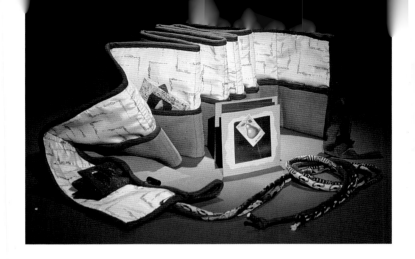

Susanne C. Scott

BOOK OF BOOKS
Open, with cord: 85½ x 8 inches (217 x 30.5 cm)

Silk cotton, metal synthetics; accordion
binding, hand and machine stitched

PHOTOS BY JIM FERREIRA

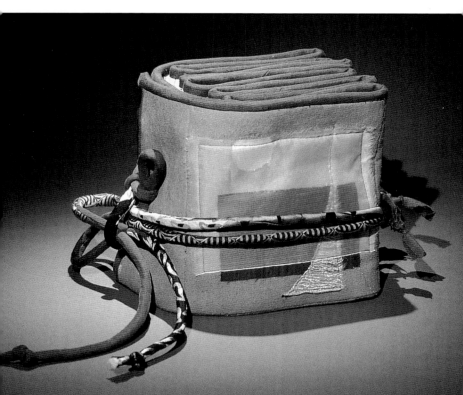

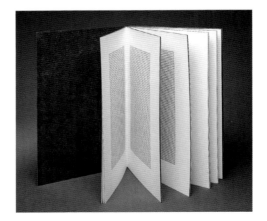

Peter Koch

UR-TEXT VOLUME III

16 x 10½ x 1 inches (40.6 x 26.7 x 2.5 cm)

Mohawk Superfine paper, acid-etched zinc, brass, braided Dacron thread, aluminum, various metals; hand bound by Daniel Kelm, letterpress

PHOTOS BY ARTIST

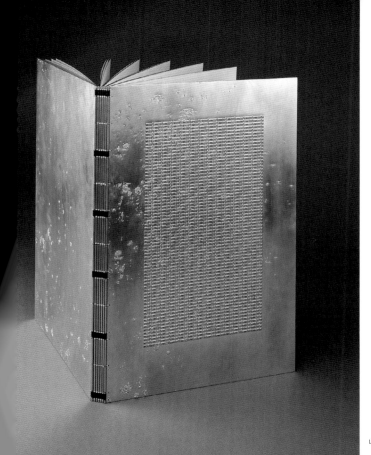

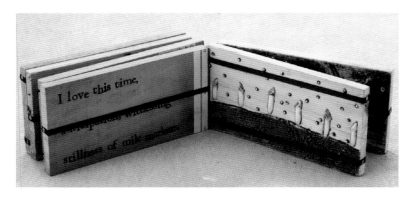

Lisa Beth Robinson

NOCTURNE
4⁷/₈ x 2³/₈ x 2¹/₄ inches (12.4 x 6.1 x 5.7 cm)

Mixed media, wood, steel shot, deer teeth,
star anise; Jacob's Ladder binding

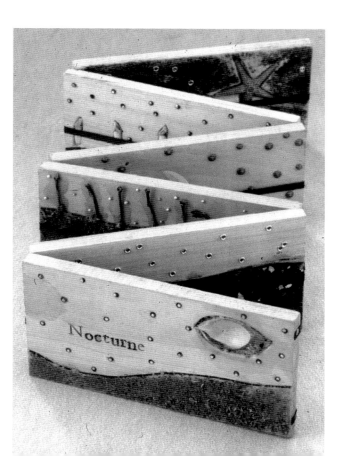

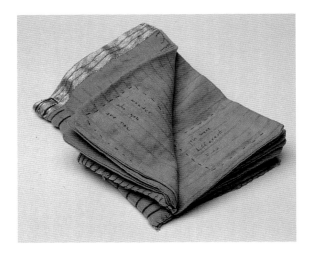

Aimee Lee

SARI BOOK
7 1/2 x 5 x 1 inches (19 x 12.7 x 2.5 cm)

Sari cloth, thread, flax seeds, tea bags; pen on cloth, hand sewn

PHOTOS BY EDWARD DANIEL

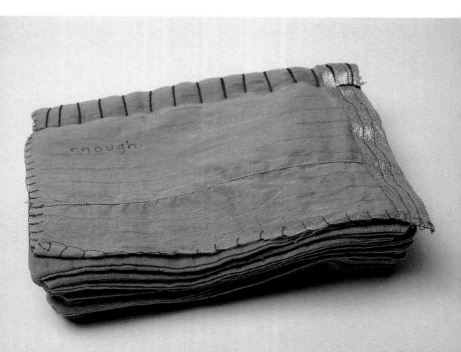

ARTIST INDEX

Enjoy more of the books in the
LARK STUDIO SERIES